1988
Happy Birthday
Matt!,

Here's some beautiful pictures
for you, to inspire you to
create more of your own
great photo's.

Love,
Todd

THIS BOOK is dedicated to the late Meröe Marston Morse who was Director of
the Special Photographic Research Division at Polaroid Corporation
from 1948 to 1969, and who contributed greatly to
the improvement of the uniquely beautiful black and white materials I used
for making these pictures. Meröe also enriched the worlds of her co-workers, and mine,
with her spiritual beauty and the rare gift of her uplifting presence.

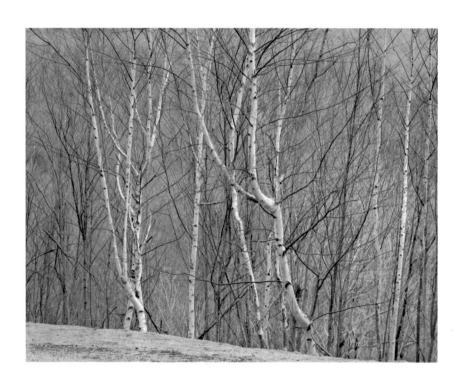

A POLAROID BOOK

NEW YORK GRAPHIC SOCIETY BOOKS · LITTLE, BROWN & COMPANY · BOSTON

SEASONS

Photographs and essay by

PAUL CAPONIGRO

This book was prepared and produced by the Publications
Department of Polaroid Corporation.

First edition
Library of Congress Catalog Card Number 88–80969
ISBN 0–8212–1703–8

Cover: (detail) Redding woods, Connecticut, c. 1968

New York Graphic Society books are published by
Little, Brown and Company (Inc.).

Published simultaneously in Canada by
Little, Brown & Company (Canada) Limited.

PRINTED IN THE U.S.A.

SEASONS

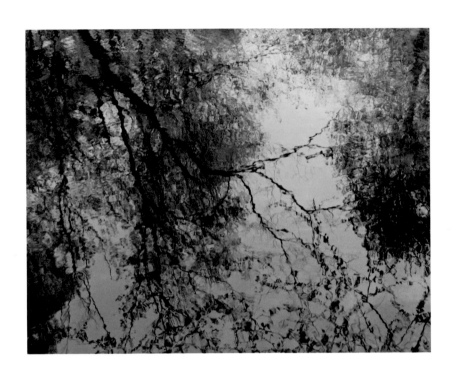

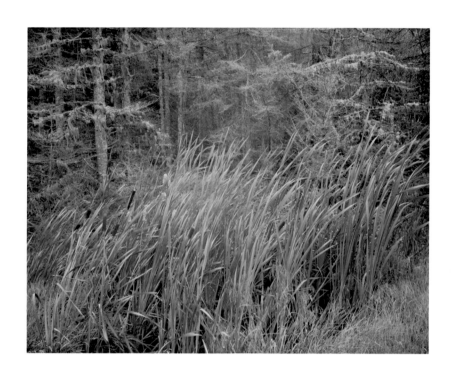

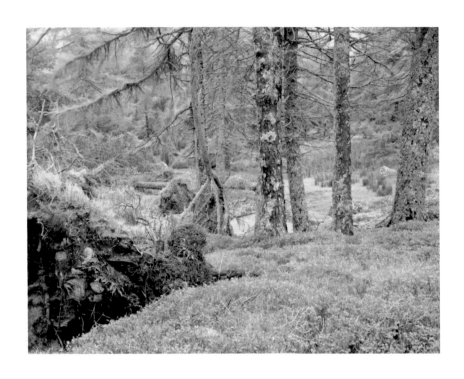

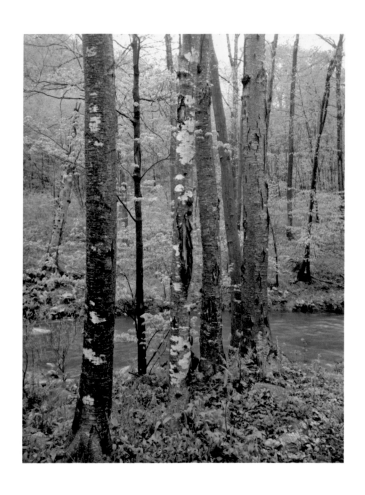

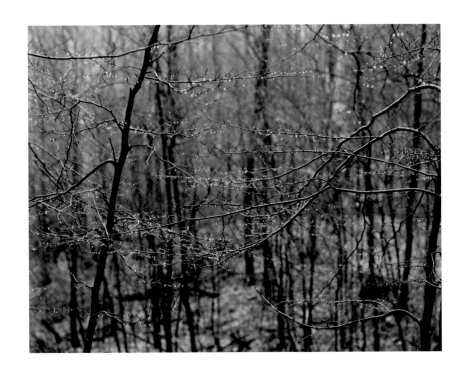

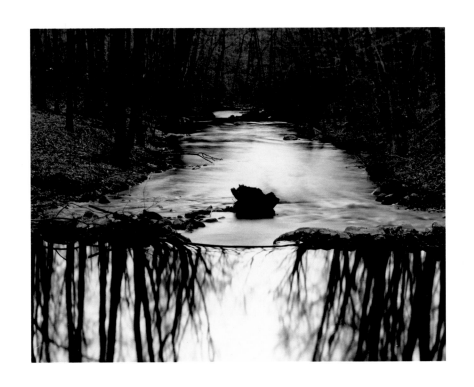

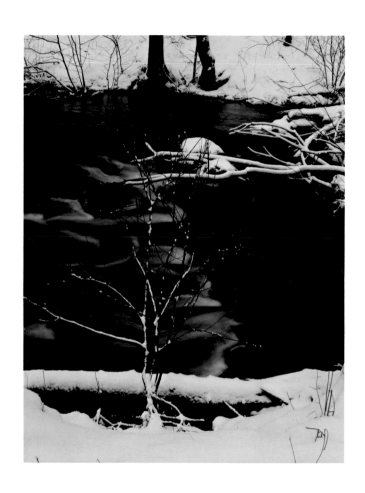

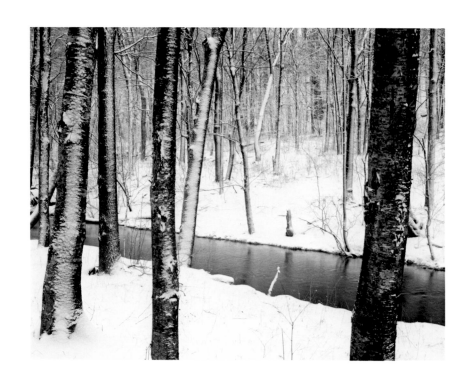

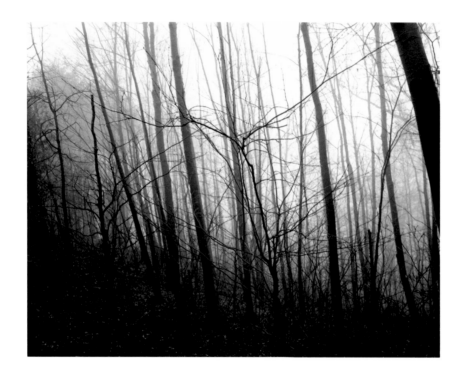

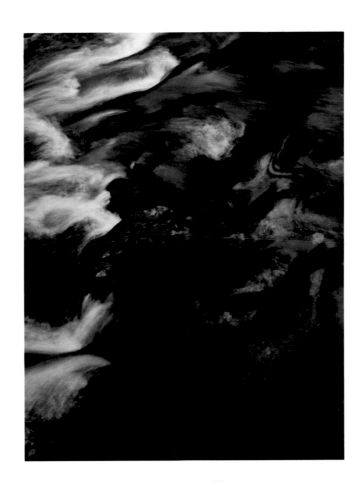

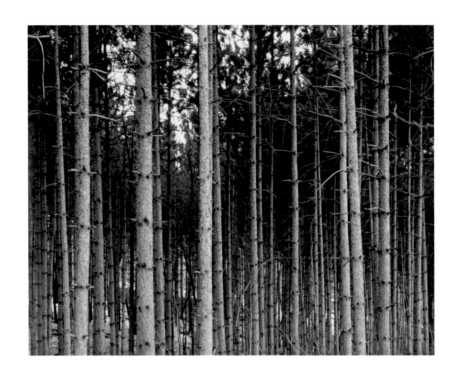

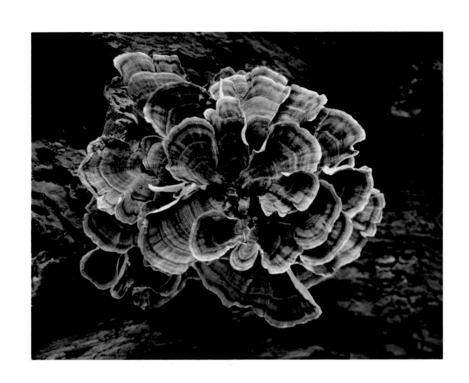

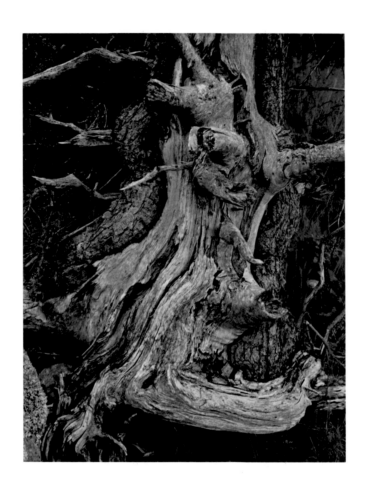

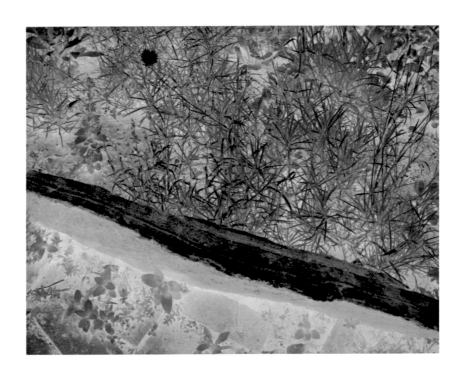

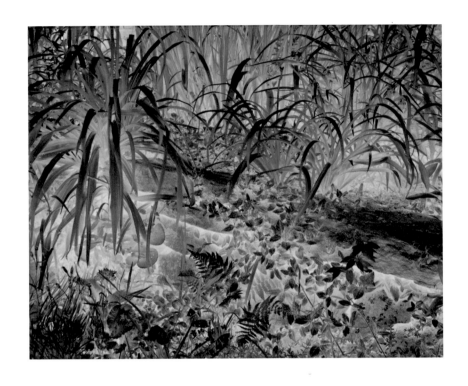

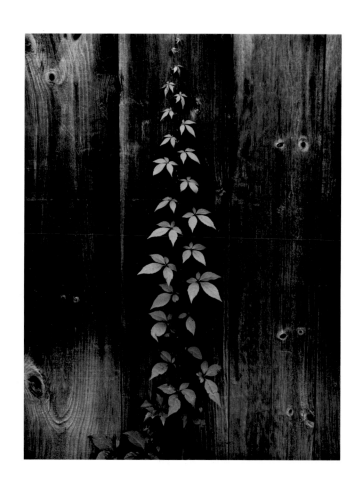

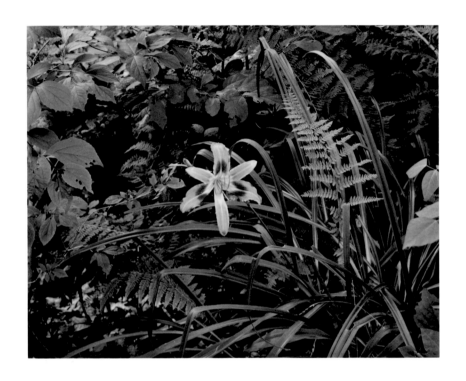

18.

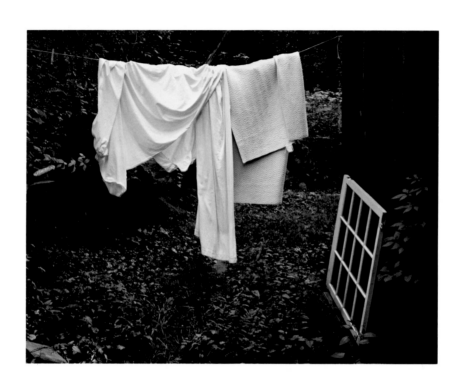

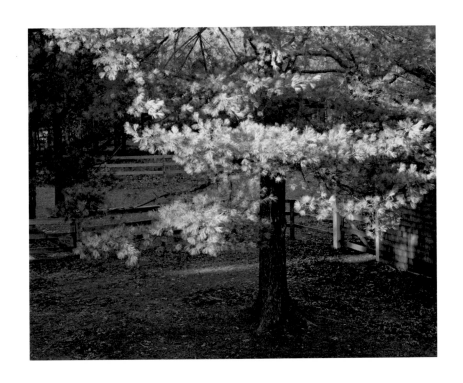

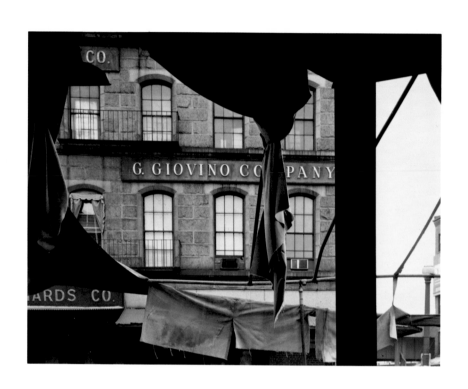

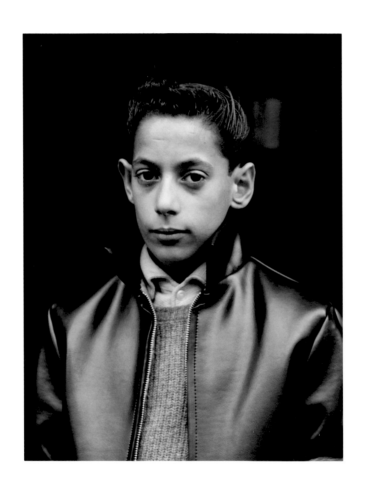

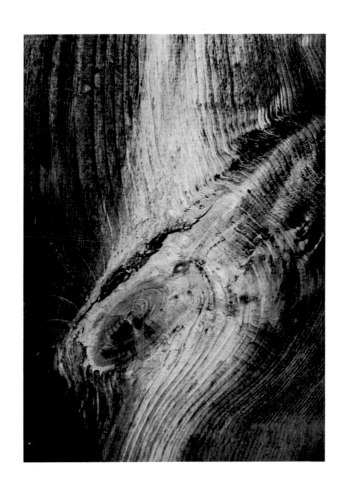

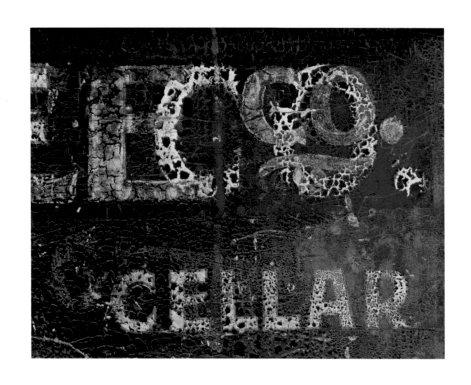

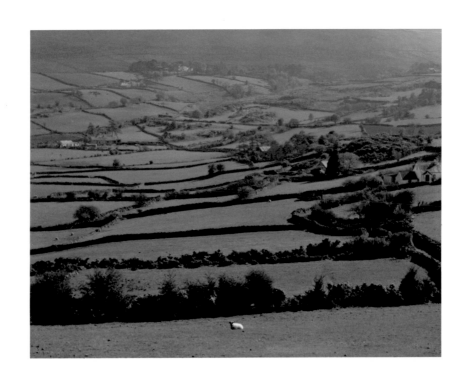

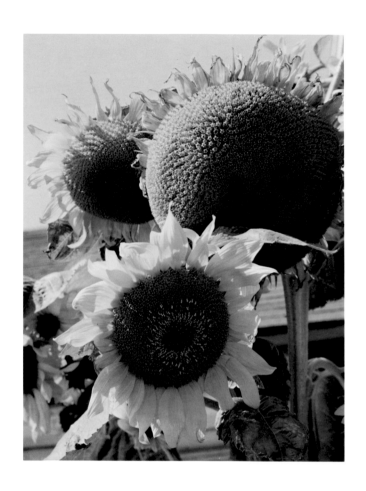

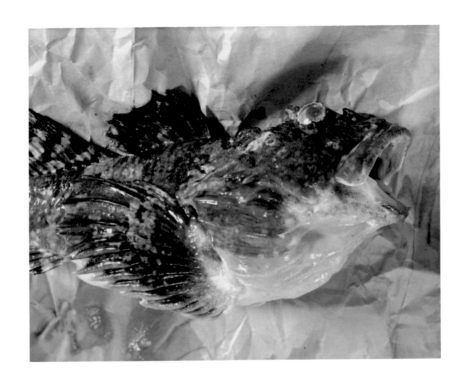

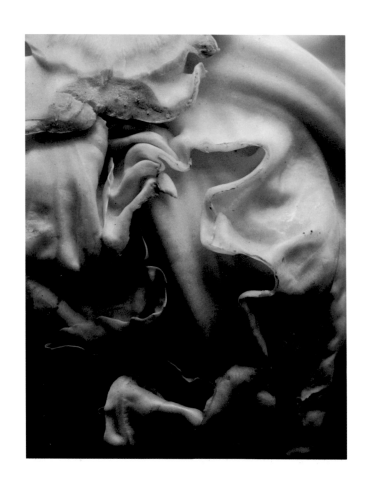

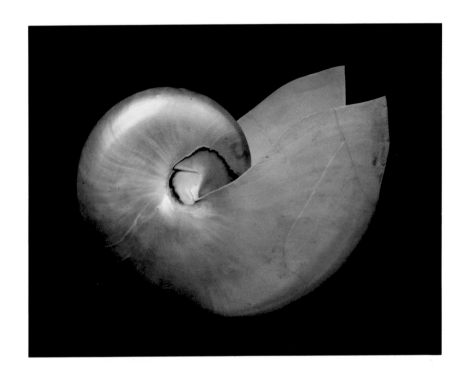

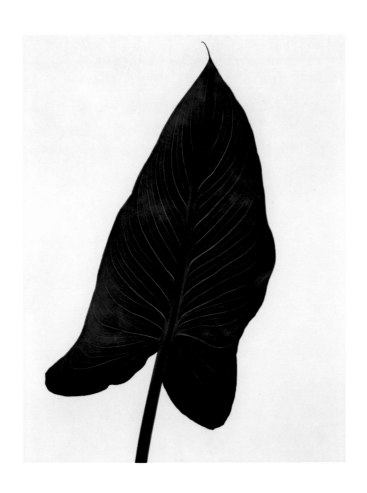

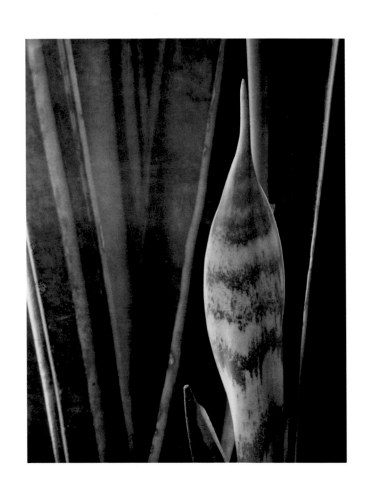

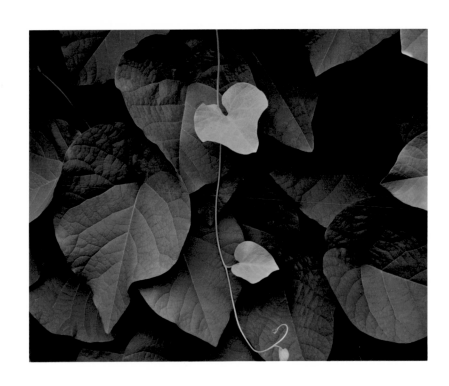

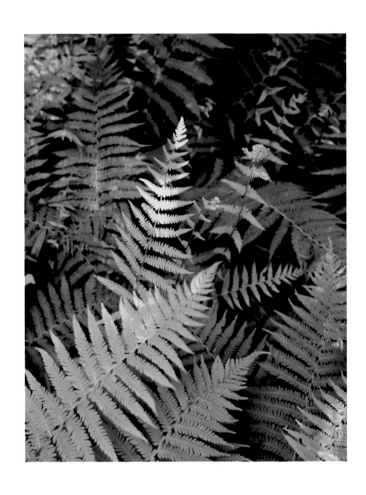

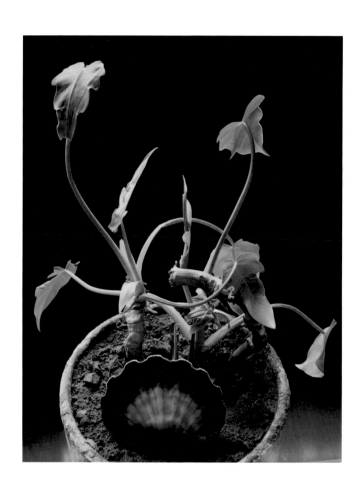

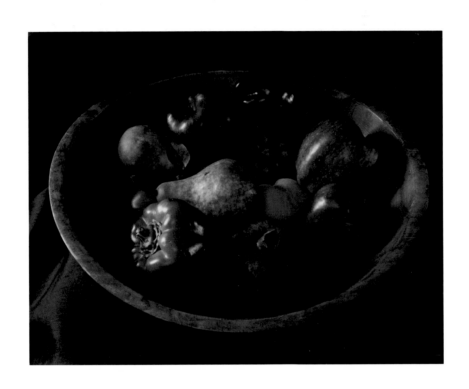

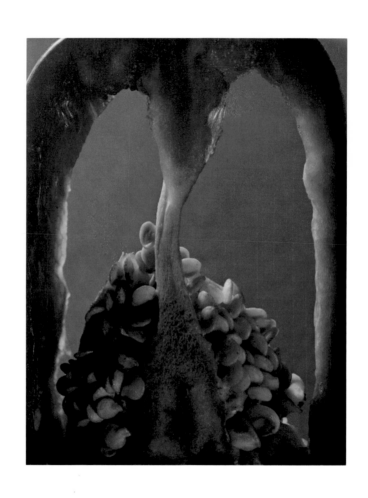

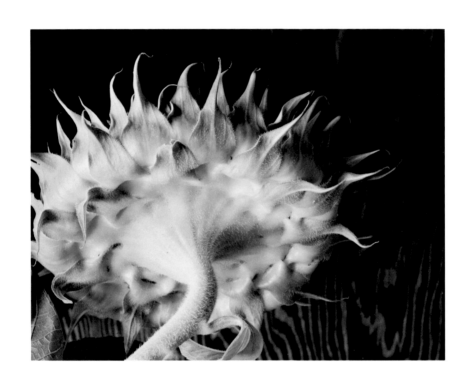

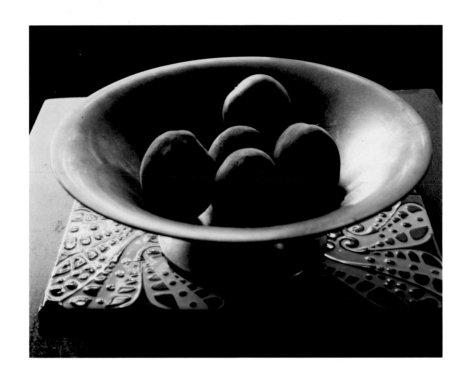

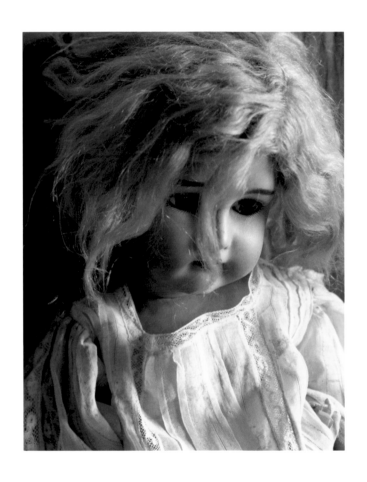

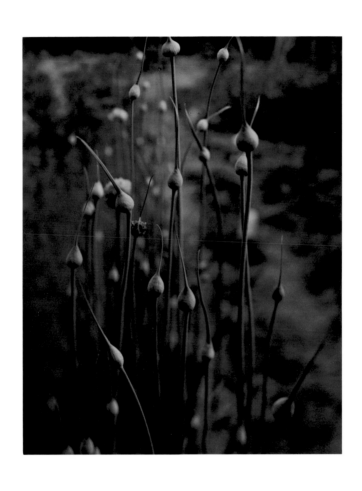

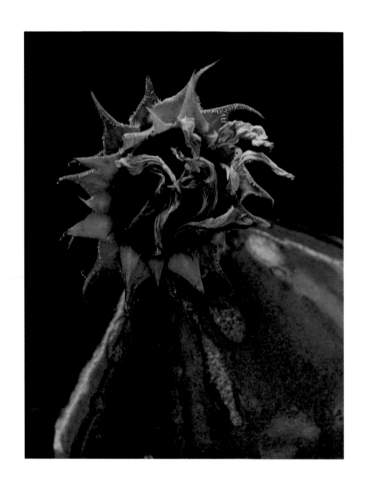

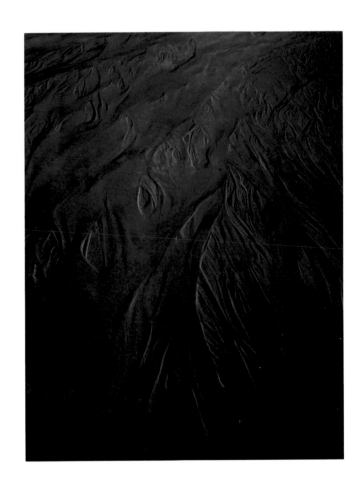

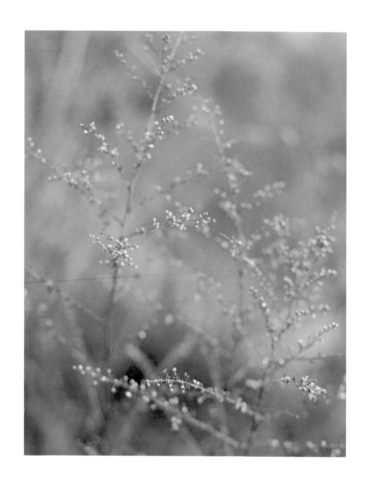

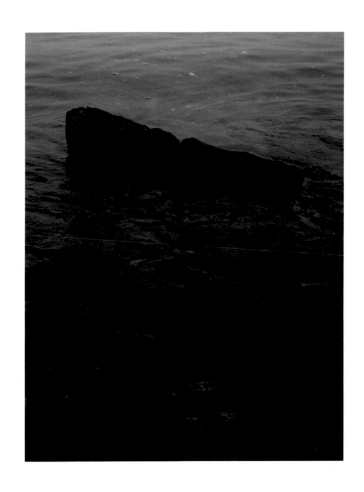

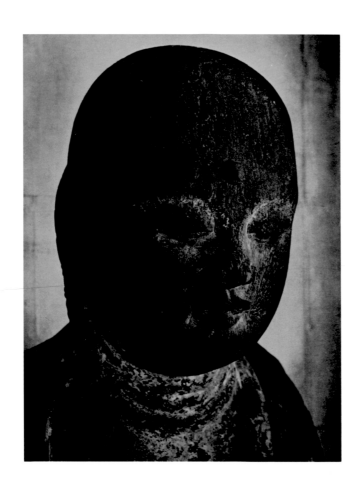

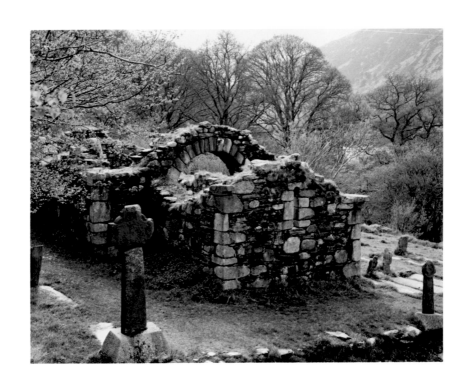

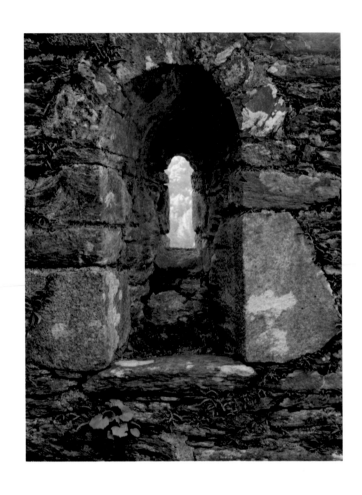

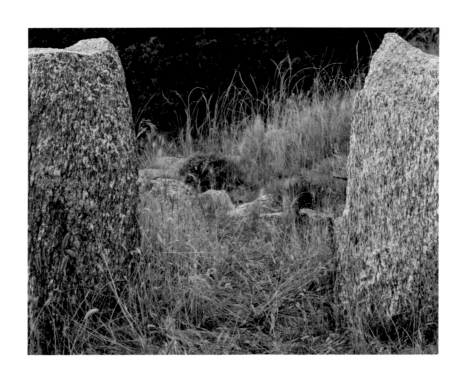

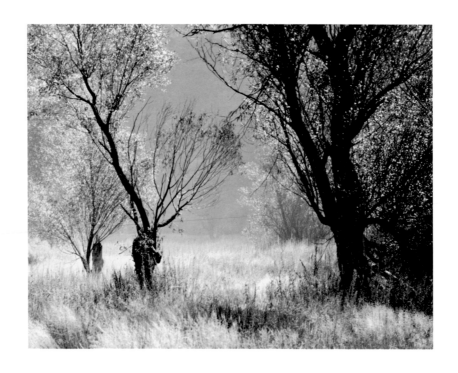

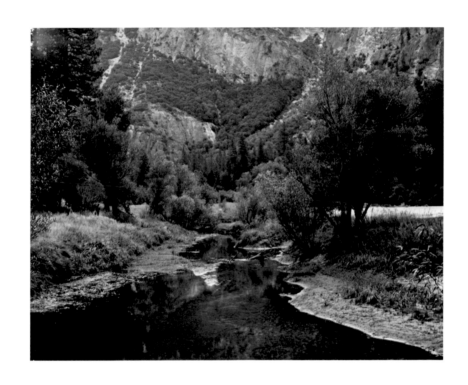

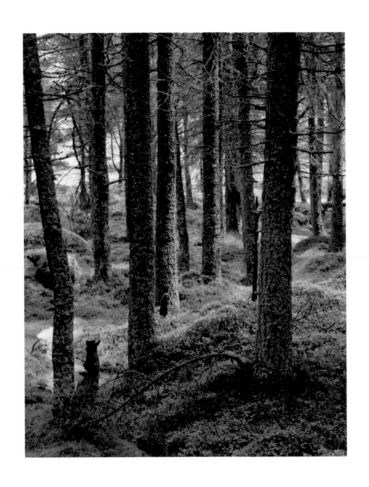

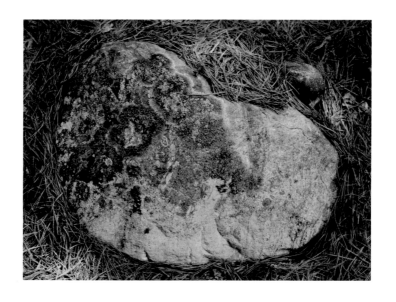

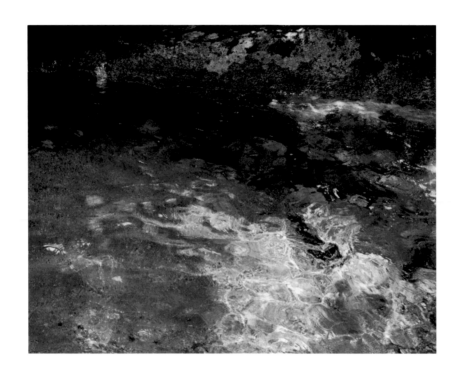

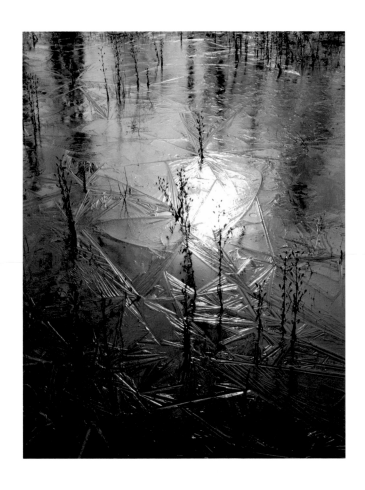

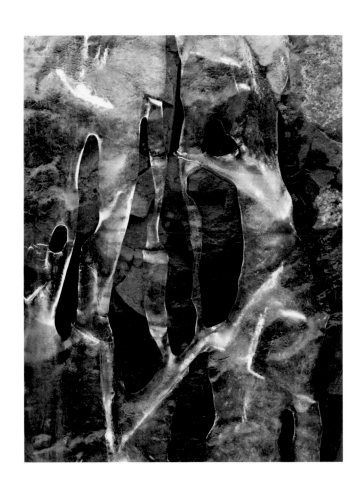

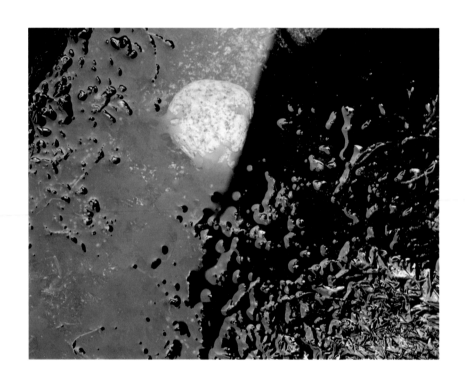

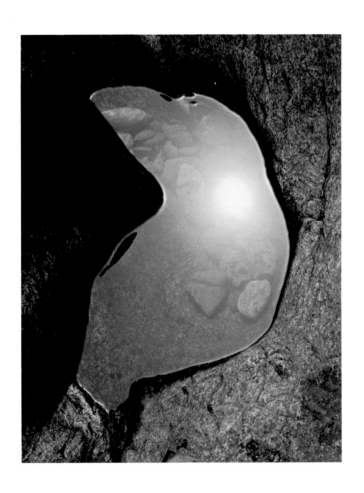

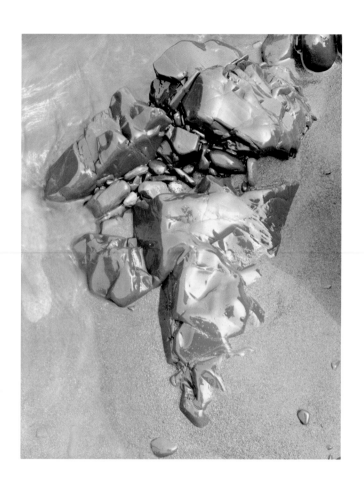

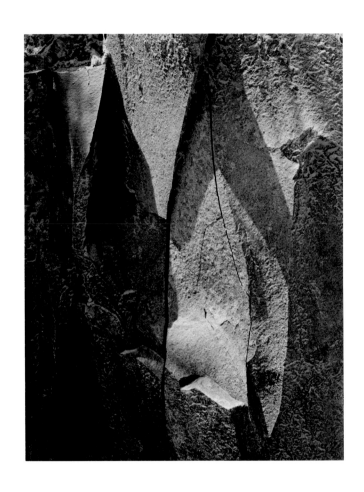

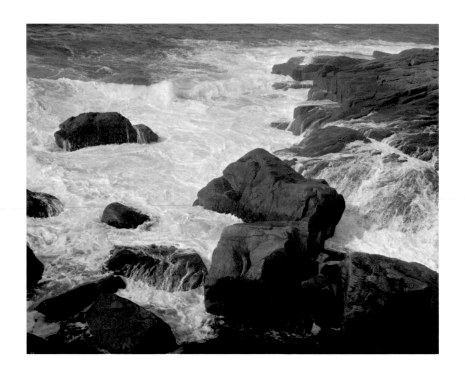

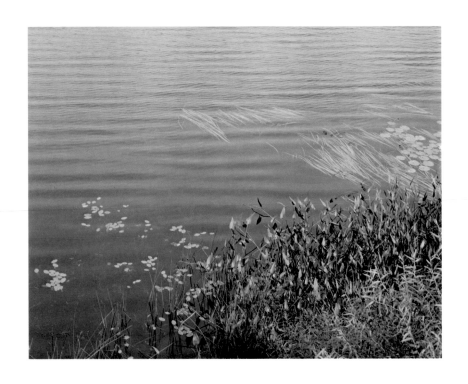

THE PHOTOGRAPHS IN THIS BOOK reflect my childhood experiences in New England: the sparkling, sandy beaches on bright days; the flat light of overcast skies that releases objects from their shadows; the hot, horizontal summer air of city streets; the country farms visually rich with tender new growth or colorful harvests.

As we grow older, the freshness and clarity of our youthful days seem truly extraordinary. We have not yet developed the protective barriers that, as adults, we maintain in order to function (and barter) in the world. My childhood was a time of wonder, and I cherish those years for that special quality of unencumbered perception. Every summer I would wait impatiently to be released from the prison of the city by my father, who took the family to the woodlands of Maine. He would rent a cabin near a lake, and here my brother, sister, and I would swim, fish off the boat dock, paddle canoes, and soak up the sights and sounds of trees, water, sky, and the creatures that abounded. The pink-bellied, shiny black leeches of the lake remained beautiful to me despite warnings from adults about their unique function; and the turtles that suddenly rose up in the lake were greater spectacles than any of the Walt Disney movies we watched on Saturday afternoons at home. Movements in the water seen through the grasses at the lake's edge were especially mysterious; then the surface would burst, revealing finned creatures with a variety of shapes and colors that surpassed the tepid illustrations of our schoolbooks. Each day in the wilderness was filled with miracles. Clear light, summer clouds, rippling water, and sudden storms seemed as much a part of me as breathing and affected me at times like a gentle rain etching messages on the surface of the lake.

During these years we also made annual visits to the farms of relatives in Connecticut. They are memorable because at some point during our stay a parent or relative would produce an interesting small black box that fit comfortably in the hands, hold it at waist level while peering down into it, and ask those assembled in front of it to stand still and smile. My strongest memory is of my grandmother, who used the camera with an air of purpose. My eyes seldom left her hands as she unwrapped the yellow paper from a roll and placed it inside the camera,

which she aimed and clicked; she later removed the roll and ceremoniously delivered it to the drugstore. In my child's mind the pharmacist seemed to be in league with grandmother, and it was like magic when the black-and-white rectangles arrived revealing images of ourselves. In one of those first snapshots, three curious children are lined up against a yard fence; in another I sit with a shy expression and tousled hair between my brother and sister on the front steps.

At some point I could not resist asking to try the Kodak Brownie, and one day, after my grandmother had neatly arranged us, she called me to her. With patience and authority she explained how to take the picture. "Hold it steady and straight, look into the finder to arrange your subject, then press down on the silver lever at the side of the box," she said. On hearing the muffled sound of the Brownie shutter beneath my finger, I felt the thrill of capturing my first picture.

I felt that same excitement the first time I was taken to the studio of a professional photographer for a formal portrait, and again when a street photographer knocked on our door, offering to take unusual pictures of us children. Clean clothes were donned, hair was slicked close to the scalp, and a washcloth was passed briskly over the face. In the yard we were greeted by an amiable man standing behind a large, bellowed box, and my excitement exploded when I saw that the photographer's paraphernalia included a shaggy pony. The cameras used by both the studio and street photographers were much larger than the family Brownie. Each stood on three legs and had a larger shining disc than ours, and our portraits were mysteriously preserved behind the glass eye. No drugstore was involved in this process, and so I was impatient to know how the pictures would come back. Within a few weeks they were delivered to our house and proudly unveiled. These were not the small, white-bordered rectangles that fit easily in the hand, but much larger prints tucked into eggshell-colored vellum folders with an etched gold line. The occasion left an indelible imprint on me.

Around the age of four I discovered another, equally mysterious box, this one much larger and fashioned of fine mahogany wood. The magic came from turning knobs instead of film

spools. I was spellbound by the emotional substance of sounds that I heard coming from the radio, but unable to question my parents about what was affecting me. I eventually realized that what I heard was a symphony orchestra. This experience was gradually clarified for me through my frequent visits to the home of my father's brother, who was a pianist. After listening to my uncle play both popular and classical music, I began to differentiate the deeper intentions of symphonic form and found I was irresistibly drawn to it.

My enthusiasm for photography was more than a novelty and did not pass away, but lay dormant for a period as other concerns occupied me. During my grade school years a curious event occurred when, after a routine eye examination, the doctor gave me a green visor to protect my dilated eyes from the bright daylight. While trying desperately to decipher the blurs on the classroom blackboard, I played with the small, decorative holes in the visor. While inadvertently looking through a perforation with one eye, I was astonished to find that this tiny hole brought everything into sharp focus. I alternated the blurred vision of my dilated eye with the clarity of objects viewed through the small hole, until the teacher interrupted my experiment. I had encountered the "f-stop" principle at an early age, but little did I know that it would later play such an important role in my life.

Although as a child play was the primary staple of my life, and I played to the capacity of my vigor, I was haunted by the mysterious, hidden worlds revealed by those magic boxes—camera and radio. These instruments held forces I looked forward to when the night dismissed everyday events. In those early years my inner life was shaped by acknowledging the intangible forces of light and sound, which both deeply disturbed and strongly attracted me. By the age of ten I was asking for a piano in order to further explore the world of sound.

While I was a student, life began for me on the other side of the large classroom windows. Since I was disinterested in most of the lessons, my attention was frequently riveted on the play of birds and squirrels in the trees or the progression of the seasons with their various moods and colors. At the end of each school day, rather than returning home immediately I often made a

detour to the nearby ocean shore. I felt a sense of elation simply watching the waves break on the beach at my feet or searching tidepools for shells and rounded stones while listening to gulls scream overhead. The roar of water during a storm and the feel of damp salt air on my skin meant more than most of my schoolroom lessons.

One day, on returning home from one of my seaside visits, I remembered my grand-mother's Kodak Brownie, and the portraits made by the itinerant photographer. I had acquired a piano, and now also wanted a camera. The idea of becoming an artist was persistently asking for expression.

I devoted ample time during the years from age twelve to sixteen to gathering the materials, equipment, and skills needed to begin to express myself. I worked with several piano teachers to learn technique. And at first it made no difference where I aimed my camera: I photographed cloud formations, the boys on the street corner, and my sister's acrobatics on the beach with equal enthusiasm. I was so elated just to have impressions on film that I once sent my brother out with my camera to take pictures at the nearby racetrack, where we both earned money by "walking the hots," or cooling the exercised thoroughbreds.

My first roll of film was anxiously delivered to the drugstore. On getting the pictures back, I saw that although I felt alive when using the camera, the resulting prints were dead. I tried this procedure a few more times hoping the prints would "come out" better, but then decided to visit the camera shop for a booklet on *How to Develop and Print Your Own Pictures*. I lost the images on the first roll I processed by immersing the film in the "fixer" before the developer, but was not discouraged by this mistake. I was certain to encounter more disappointments in the learning process.

A neighborhood pal frequently took me along on his visits to the Revere Beach amusement park to see his girlfriend, who had a job hand-tinting photographs. These were portraits made with the subjects standing behind a humorous cardboard cut-out and inserting their heads into the opening. Noting my intense interest in pictures, the proprietor invited me into his darkroom

to learn the method of fast film processing. Although it was a tiny, foreboding place, dark and reeking of citric acid and the rotten-egg smell of Flemish toner, I accepted his offer of a job. The experience helped me improve the contact prints I made in the makeshift darkroom I had installed in the cellar at home.

After a period of shooting and processing my own pictures, my desire to improve prompted me to visit the local portrait studio more often than the seashore or woods. The two owners used large cameras and 8 x 10 sheets of film, and their retouched negatives produced smooth tones in the prints. In return for running errands and sweeping floors, I was admitted to the darkroom; here, in the glow of red safelights, I watched the magic of light interact with the mystery of solutions. The quality of these professional prints was compelling. After studying the design of their darkroom enlarger, I attempted to build one myself, and spent weeks working with inadequate tools and little technical knowledge—with dismal results. My parents must have been touched by my effort because on Christmas morning I found a "Sun Ray" enlarger under the tree. This gesture of support would open greater possibilities for me.

I apprenticed to the portrait photographers and eventually assisted on their candid wedding shoots. My first solo shoot was a success, and I soon became an old hand at candids. At the time I was living in Revere, Massachusetts, where three ethnic groups—Jewish, Italian, and Irish— offered a broadening experience through the unique traditions of their cultures. I once enjoyed the fervent voice of a cantor while shooting a Bar Mitzvah in three-dimensional color. At the Italian weddings I wove my way through exuberant guests, trying to arrange group portraits of the extended families, who were not uncooperative, but simply more interested in participating in the festivities. The Irish, although no less enthusiastic in their celebrations, were more willing to pose for the camera. The fiddles and accordians of the Irish musicians added an intriguing pulse to the gatherings, one I would experience again in Celtic Ireland.

During this period a neighbor returning from the army invited me to enjoy a "photographic find" he had made in an abandoned schoolhouse in Germany. The treasure was a large box filled

with 5x7 photographic glass-plate negatives dating from the 1880s, most of which were panoramas of towns and farmsteads. I was curious about the German handwriting on the envelopes, *Die Belichtung war über, unter, oder richtig.* My neighbor explained it meant that the negatives were either over-, under-, or correctly exposed. He loaned me several of the accurately exposed plates to print, and for weeks I enjoyed vicarious journeys in a foreign land.

Eventually, by working weekends at my father's business or the portrait studio, I earned enough money to buy a Speed Graphic camera, which I put on a tripod to make pictures of the sculpted rocks worn smooth by the sea. Over these years the coastline at Nahant, Massachusetts, was a haven of solitude and a rich quarry for some of my best photographs.

Work at the keyboard and discoveries through my camera enriched my days, until high school graduation compelled me to decide whether I was going to be a photographer or a pianist. One year at the Boston University College of Music convinced me that I was not suited to the academic world, since I felt frustrated spending more time with books and theory than at the piano. I left university studies, but not before making a superb find. I had been listening to many piano students at Boston University and discovered that a certain group was making extraordinary music. As it turned out, they all studied with the same teacher, Professor Fondacaro. I asked him to accept me as a student, even though I was leaving the university for a job in commercial photography. He agreed, but insisted that I not play music for one year because the years of high school piano lessons had implanted too many wrong approaches to the keyboard that had to be eradicated before he could begin instilling new habits and introducing me to the world of good sound. He eliminated the long, ineffective practice sessions and instilled a new understanding that enabled me to eventually achieve a unique tone and finger articulation and brought hope for a more profound experience at the piano. This year of being constrained from expressing myself at the keyboard introduced me to the ambivalent nature of conflict. Although unpleasant in one aspect, it could also bring unexpected gifts.

While Fondacaro's techniques enabled me to command subtlety at the keyboard, the super-

visor at the commercial lab was teaching me printing skills that enabled me to start with even very difficult negatives and achieve prints that were pleasing to the eye. During lunch hours I took advantage of the expertise of the men in the lab regarding questions I had about the relation of the negative to the print. One of them described a trick he used to improve the quality of his negatives. "On the night of a bright moon," he confided, "load your film into the holders in a room with the shades not fully drawn. Allow just enough of the subdued moonlight to affect your film without seriously fogging it." He was introducing me to a practice known as "preexposure," which I was to learn much later through Ansel Adams's famous Zone System. This consisted of subjecting the film to minimal light before making pictures in order to keep details in the shadow areas of the negative "open" and to produce a tonal quality that avoided empty blacks. Ansel recommended "shooting the sky" or an eighteen percent Kodak gray card for a specific number of exposure units, but I preferred this more romantic idea of "feeling" that one could subject the film to what was "just enough" of the subdued rays of the moon.

My life was interrupted when the army drafted me in 1953, and I was taken from the creative activities I loved. But ironically, being a G.I. Joe in an environment of rigid rules ultimately gave me access to new horizons in photography. I was sent to Fort Dix, New Jersey, for training as an infantryman destined for combat. There I successfully auditioned for the army band and was released from infantry duty. While I waited at Fort Lewis, Washington, to leave for Korea to play for the boys at the front lines, President Truman ended the Korean War. The troops were dispersed throughout the U.S. training camps, and I pulled duty at the Sixth Army headquarters of Presidio, San Francisco. Armed with my assigned instrument, I presented myself to the captain of the band, who was repulsed at the idea of having my glockenspiel pealing above the sounds of his well-trained musicians. Learning that I also played piano, he suggested assignment to the dance band at the service club. However, since I played only classical music, this was not a way out for him, so I quickly told him I was a competent photographer. Eager to be rid of my glockenspiel, he phoned the Sixth Army photo lab to say he was sending a "hot-shot" photographer over for

on-the-job training, and I was immediately transferred to Signal Corps duty.

During my first weeks at the post photo lab, I became aware of a smaller darkroom on the premises, which was used by civilian photographer Benjamin Chin. From behind his closed door there issued the constant sounds of concertos and symphonies, and I often stood nearby in order to hear the music. Noticing my frequent presence when he emerged from the dark, he finally asked why I seemed rooted to that spot. On learning it was the music that drew me, he invited me to his apartment to listen to sounds on his quality hi-fi set. And after treating us to good music and an excellent Chinese meal, he showed me some of the most beautiful photographs I had ever seen. I was unfamiliar with the names of those who made these exquisite prints, but Ansel Adams, Minor White, Imogen Cunningham, and others whose work he showed me that night were to have as profound an effect on me as Fondacaro's piano method. I remember the Edward Weston prints for their glowing luminosity and the Minor White photographs for their strong emotional power. Eventually I showed Bennie some of my own nature photographs, and he expressed surprise to find in them a strong affinity with the work of the West Coast photographers.

During the next six months Bennie helped demystify Ansel Adams's Zone System, which taught a technical method of achieving beautiful photographic prints and the concept of previsualizing images. He carefully led me through the labyrinth of sensitometric language and disentangled much useful information to help my technique. Bennie loaned me his 4 x 5 camera equipment and Weston densitometer, and also helped me to understand the use of light in my prints.

At Bennie's invitation I attended a farewell party for one of his teachers at Ansel Adams's studio, where photographers Imogen Cunningham, Dorothea Lange, and other notables gathered to honor Minor White, who was on his way east. On seeing Ansel's photographs, I marveled at the love and dedication pulsing like music through the beautifully crafted work. That evening Ansel played Scriabin, Mozart, and his favorite Bach prelude on his piano, and again the worlds of sound and light merged for me. Bennie then introduced me to Minor White and suggested that

since he had now taught me most of what he knew about the technical aspect of photography, perhaps Minor could acquaint me with his way of looking at image content. Minor's approach to photography was more psychologically oriented. These photographers believed that the print could be a vehicle for subtle and fine personal expression, and that the individuality of each photographer would be evident in the final results. Learning to tone my prints with selenium had been revelation enough, but the idea that one's photographs could be a mirror of the self was intriguing. Unfortunately, Minor was leaving California to begin work at the George Eastman House and Rochester Institute of Technology, but I was to catch up with him at a later date.

A particular incident made me realize my love for the silver print one day when I was on K.P. duty at the army mess hall. I had seen the original prints of Edward Weston's eroded rocks at Point Lobos, which expressed a profound sense of the substance of stone and of light, and in the midst of my mess hall drudgery my eyes fell on pieces of soap that through the erosion of water had taken on exquisite shapes. My recognition that I could connect emotionally with a piece of soap, that I could feel a connection with such a simple object, transported me. I imagined the way in which I would photograph the soap, and mentally linked the uniqueness of the silver print with this mundane material. The idea of transforming the subject, and not merely recording it, was taking hold; I was eager to use Bennie's camera in my off-duty time to produce negatives that would allow me to experiment with the world of translations. These months of music and photographic work in San Francisco inspired and nourished me, but more conflict was to reveal further horizons.

The top sergeant of the lab and I were at odds. He resented the fact that I was furthering my personal photography using army time and materials. Frequently he would assign me to duties outside the lab, such as taking aerial views of army posts throughout California, and I was convinced it was he who effected my untimely departure from San Francisco by shipping me to another post. I felt exiled from the nourishing photographic community in San Francisco, and banished to burn in the isolation and heat of Arizona's Yuma Desert.

I had almost a year of duty to serve in this arid and sparse, but exquisitely tense, desert land. Resolving to use the time to improve my photography, I devoted myself to exploring its spaces and my medium. The desert was not an easy environment, but it did give me the chance to refine the known and to explore the unknown. Only minimal interaction with other soldiers was necessary, and so more personal time, as well as army materials, were at my disposal. I had brought along Ansel Adams's basic photography books and wrote home for my Speed Graphic in order to spend the greater part of my time working alone in the desert. While there I submitted several photographs to the Fifth Interservice Photography Contest, including some desert views and a photograph of a spiral staircase I had taken in San Francisco's city hall prior to my departure. All contest entries, I later discovered, were sent to San Francisco to be judged. I was pleased when awarded an honorable mention for my staircase photo, and it meant even more when I discovered that Ansel Adams had been one of the judges.

After coming to terms with the barren terrain, I photographed not only the vast panorama, but the details of windblown sand that carved miniature canyon walls on which light played, and the bones of such desert plants as cholla and ironwood trees. It was here, while sitting on a high place and scanning the panoramic views, that a vision of my life suddenly unfolded before me. The deep silence of the desert caused an equally deep place to resonate within me. This meditative state enabled me to see many events of my life projected on the vast screen-like atmosphere of the desert. Actual events of my past took on new meaning in relation to one another. The desert as mirror had pointed to hidden dimensions within me.

It was a rich and productive year of exploring a unique land; as it drew to a close I was relieved to know I would no longer have to live under military regimen, but regretted leaving the desert so soon. I contrasted the intimate, lush land of my New England childhood with the endless spaces of cutting light and hot sands, where brittle details were held in unremitting silence, and realized my deep attachment to both places. I understood that nature would nourish me anywhere.

My reluctance to leave the Southwest desert was somewhat allayed by my eagerness to return to my keyboard studies. I also enrolled at Boston University night school for a few classes in art history, and took a job for the remaining evenings of the week at a well-known night spot on the outskirts of Boston. The famous singer Vaughn Monroe owned and often sang at his restaurant "The Meadows," where I had the job of again making "fast fotos." While Vaughn crooned his favorite ballad, "Racing with the Moon," a young lady prowled the dining room making flash photos of couples and groups. It was my duty to develop and print them in jig time. This offered a strange contrast to the careful craft of my desert photographing, where time spread easily before me or stopped altogether. At Monroe's establishment I was shut in a tiny room and bombarded by sheets of film, which I processed in half a minute, placed in the enlarger wet, and dried without the luxury of adequate washing. The photographer collected a batch of dry prints, ready for delivery, each time she returned with more exposed film for me to mangle.

I was making progress with my piano and testing the new photographic techniques along the rivers and shores of Massachusetts, Maine, and New Hampshire. Nevertheless, toward the end of 1956 I again felt drawn to the clear light and open landscape of the West. I yearned to return to that stark, polished mirror called the desert, which offered a place to reflect, and I also wanted further contact with the West Coast photographers. I took a bus to Salt Lake City to meet an army buddy, and from there we set off in a small truck equipped with camping and photo gear. We camped at Moab and Escalante of southern Utah, and meandered through the parks of Bryce Canyon and Zion, sleeping under the glittering dome of desert skies. I listened to my friend's occasional recitals of his favorite poetry while watching the indigo skies overhead slowly displace the bright constellations. I alternately dozed, caught phrases of rhymed lines, and noted the positions of stars in an invisible arch. I particularly recall the crisp air of desert mornings, and our carefree existence in a land of raw beauty untouched by manmade structures.

85.

Reluctantly, I left Utah and boarded a bus for California.

Returning to San Francisco I realized that the time with Benjamin Chin had involved more than just exploring the technical aspect of photography. In addition to the photographers living there, I found a vibrant community of other artists, and it made me aware of how nourishing the right environment can be for the creative individual. I found a small apartment as well as a job printing in the darkroom of an advertising company, and I rented a piano to share music with my fellow artists. Most of my spare time was spent exploring and photographing new landscapes north of the Bay Area. Besides the good company of other photographers, there was the stimulating atmosphere of San Francisco itself, a big city that had not yet suffered a population explosion and its attendant difficulties. One could move about with relative ease, and the city, built on seven hills, was a constant visual feast. I particularly enjoyed watching the fog mysteriously appear and disappear in the surrounding bays and, at night, hearing the deep, resonating fog horns.

I could have continued in this way, but after eight months I was unexpectedly agitated by the need for change. I could not ascertain whether it was merely restlessness or dissatisfaction within me. It was not until I viewed a retrospective of the work of Morris Graves that I realized it was dissatisfaction. I had been steeped in the Grand Landscape tradition of photography, which inspired its devotees to make beautiful compositions and technically fine prints; but I was becoming aware that I also needed to express another dimension in my work. Morris Graves's paintings and watercolors, with such titles as *Moon Mad Crow in the Mist* or *Little Known Bird of the Inner Eye* or *Joyous Young Pine*, had an immediate impact. The mystical element, the clear expression of an "otherness" moving gracefully from one painting to another, told me that Graves was intoxicated by beauty and directly in touch with mystery when he worked. Although there was an occasional measure of "magic" in the work of the West Coast photographers, I did not find it frequently enough in either their work or mine to satisfy me. I realized that I wanted my work to be imbued with that very sense of "otherness," which I had been encountering in various ways throughout my life.

Having decided to leave the community, I remembered the photographs of Minor White and a statement he had made about photographing a thing "not only for what it is, but for what else it is." Minor's intuitive method of working and his psychological bent in image-making made me feel I should eventually try to work with him. After one final photographic trip through Yosemite and the High Sierras, I moved back to Boston. I needed time to work alone and to order my experiences.

In Boston I was careful not to fall into recurrent patterns that might divert me from my work. I simplified my needs by renting a modest one-room apartment on Newbury Street for shelter and darkroom, and set out to acquire clients by creating a portfolio of architectural studies, ultimately receiving assignments from several Boston architects. It did not take me long to install an upright piano, and again I gravitated to the artists of the community for an exchange of ideas. Ample time was reserved for lessons with Fondacaro and for photographing the woodlands and seacoast.

In 1957 I contacted Minor White in Rochester, and he invited me to 72 North Union Street, where I joined the photographic community. Photographers and curators from the George Eastman House and select students of Minor's from the Rochester Institute of Technology gathered at his apartment to discuss one another's work. Minor was steeped in the ideas of Zen, and his spacious but sparsely furnished rooms reflected this. Oriental brush paintings hung on the walls alongside his own photographs. His work seemed to be that of a meditative, intuitive person, and I sensed that only intense dedication could have produced the fine silver prints I saw. To these superbly crafted photographs of the West Coast tradition was added a large measure of Minor's concerns with matters of the spirit. A very gracious host, he added to the music that constantly issued from his speakers the aroma of good cooking from his kitchen. Minor himself graced the atmosphere with an abundance of enthusiasm. I was given a bed and told the household ran on whatever donations one could offer, as well as the performance of daily chores to keep the place clean and orderly. I was to help him in the darkroom when necessary, and in the kitchen, cooking

Chinese style as well as learning the joys of dishwashing and floor-mopping. Minor's house-hold was a magnet for a steady stream of people who were involved with photographic work, and it provided a constant affirmation of that work. Rochester also meant an opportunity for me to explore the archives of great photographs in the collection of the George Eastman House.

Minor was involved with—and enjoyed discussing—several philosophical systems and disci-plines in his pursuit of what he termed "spirit in photography." The concept of the "Equivalent," as practiced by Alfred Stieglitz, was central to these discussions. In retrospect it seems to me that Minor was attempting in various ways to introduce the students to the intuitive aspect of image-making in the hope of activating it. We learned Minor's method of "reading" photographs, and I was often put alone in a room to look at his work until I could get past the obvious subject, however beautiful, and discover what deeper implications might be conveyed by the images. However, I wondered if, beyond recognizing that the image-maker would indeed leave his thumbprint on his work, the image needed to be so excessively burdened with "meaning." Al-though I preferred to focus on the simple act of making something that was beautiful or expres-sive, I was too young and too enamored of the overall exciting atmosphere at the time to question it deeply enough, and so gladly did the exercises and fully participated in the community's work.

While the continual discussions of Zen and related philosophies were certainly stimulating, they also tended to set up an intellectual barrier to experience. Most of the images I saw that resulted from the exercises were primarily intellectually based, and too often a student complied with formulated thinking in order to create a photograph that could be considered an "Equiva-lent." I became convinced that true "equivalence" would follow from simple receptivity and wholeheartedness of action rather than from either using a premeditated approach or trying too hard to achieve the desired effect. The work that issues from a predetermined stance has never equaled, for me, the results of quiet action and discovery. I was eventually to realize that only by freeing myself from dogma and opening up to experience could I become more sensitive to the dynamic inner world.

In the summer of 1958 Minor and Walter Chappell helped me assemble my first one-man show at the George Eastman House. Minor's request that I title the exhibition felt like a test to see if I had graduated from merely making photographs to understanding their content. I accepted the challenge and arrived at the title "In the Presence of. . . ." He was pleased with this as well as with my short statement, that my work was made "to create beauty of image."

<p style="text-align:center">* * *</p>

The following year Minor asked me to accompany him on a cross-country trip and to assist with workshops in Oregon and California. I heartily accepted, enthusiastic about the prospect of seeing new terrain. Our camping trip began in Rochester; proceeded on a northern route to Minnesota, where we stopped to visit Minor's mother; and continued on through the Badlands of South Dakota to Glacier National Park, Montana, where we spent substantial time camping and photographing. We continued photographing our way through the windswept grain fields of Idaho, visited the Cascades near Columbia River, Washington, and dropped down to Portland, Oregon, for the first workshop.

Minor's primary aim for this workshop was to acquaint the students with his method of "reading" photographs. My duties were basically to mingle with the workshop participants and answer the endless questions about the Zone System. I stayed in the background during these sessions and simply observed the varying reactions. Recalling my own earlier ambivalence, I could agree with those participants who thought that Minor often tended to impose too specific an interpretation on the photographs. I could see emerging the many problems that can arise when one uses the photograph as a psychological field. Despite differences of opinion, however, the activity could jar the student toward other possibilities in photography. Whenever possible I took the opportunity to put aside the excessive search for meaning and simply photograph. Time spent at Cape Kiwanda, near Portland, was so memorable that today, almost thirty years later, I

can recall the degree of the sun's intensity on my skin as I photographed shirtless to pounding surf and gentle sea mists.

We left Portland and photographed our way along the coast to San Francisco for the next workshop. Minor and I were the guests of Ansel and Virginia Adams for two weeks; I enjoyed playing Ansel's piano and had the use of his darkroom to process film shot on the trip. Parties with good food and friends were frequent since Ansel was both very gregarious and a generous host. During this time I sensed a slight rift between Minor's and Ansel's attitudes toward creative photography. Ansel stood firmly committed to the simplicity of revealing his subjects through light and was not interested in psychological interpretation, while Minor held tightly to his conviction that photography should be a means of revealing the psyche and spirit. Standing between two glasses of vodka being held, respectively, by Minor and Ansel at a cocktail party, I overheard Minor ask Ansel in a playful yet probing tone if he was still practicing the Zone System. Ansel responded, "Well, of course, and I understand that you are now practicing the Zen System." With this exchange they aired their quiet conflict simply and with good humor. I felt released from any need to take a side. For me both ways could dovetail, and the degree to which one delved into it was a personal matter. I had been inspired by both Ansel and Minor, but once again found it was necessary to separate myself from the world of ideas and influences and seek my own way into the heart of the matter. Although I respected influence, I looked for its deeper roots in order to separate it from personalities.

During the return trip to Rochester, I began to realize that something had been stirred in me by the long periods of free and uncluttered time—the sweetness of simply being and doing, unattached to a need for specific results.

<center>* * *</center>

My return to Boston helped clear the way for new beginnings. After I had been alternating

my time between personal work and commercial photography for several months, I was invited to exhibit my nature studies at the Carl Siembab Gallery. Since Ansel Adams often visited Boston in his role as consultant to the Polaroid Corporation, I invited him to the exhibition. Ansel brought several Polaroid associates to the show and suggested they consider using me as a part-time consultant. This kind gesture resulted in my being hired; and not long after, seeing that I could function financially on the monthly fee, I stopped doing commercial photography to gain more time for my personal work. Tiring of my active social life in the city, I left my Newbury Street apartment and rented a place in the quiet woods of Ipswich, Massachusetts, for a modest fee and installed a new Baldwin Grand piano, which I financed over a three-year period. Three to four days per month working at Polaroid was adequate for the minimal finances I required, and this extra time enabled me to resume studies with Fondacaro and to find peaceful interludes for my personal photography.

That year a difficult New England winter brought a beautiful snow storm to Ipswich and provided the solitude necessary for working in a state of unusual clarity. The warmth and comfort of the house did not deter me from venturing to the woods to work with the beautiful crystalline mounds that transformed everything beneath them. While trudging through knee-deep snow with camera and tripod, I came upon an extraordinary configuration of tree branches laden with unusual shapes of caked snow; amidst the various shapes was the perfect image of a winged angel. I marveled at this crystal gift and carefully adjusted my tripod and camera to capture its image. With the film holder in position and ready for exposure, I leaned forward to measure the level of light. In that movement I dislodged a nearby branch, which flung itself directly at my snow angel, and I mused on how capriciously this gift had been given and taken. A beautiful image from the elements was lost, but the experience set a tone that was to last in the days to come while I roamed the woods with my camera and produced a series of negatives conveying the spirit of that snowstorm. This time was filled with magic and the peaceful work mood was as cleansing as the delicate atmosphere of the fresh snow.

For two years of this period I had been alternately making my living in Boston and driving to New York City to study drawing and sacred dancing. Because the constant travel was beginning to wear on me, I decided to move to New York to finish my studies. I sold my grand piano and obtained sufficient finances to keep from having to work while studying. Drawing interested me, as I wished to discover something about image-making through the freshness of a new medium.

During my stay in New York I also photographed, but I cared little for making photographs in the streets. Rather, I preferred the cloistered environment of my apartment, where I photographed fruits and vegetables bought at the markets. I learned the techniques of physically dealing with the pace and pressures of the streets but realized that the city extracted a price from me emotionally. I could not remain open for long periods of time to the obvious, as well as subtle, violence making up the basic fabric of the city's atmosphere.

One time while photographing a still life of fruits, my eye gravitated to the attractive shape of the single red delicious apple in the bowl, and I decided to use it as my subject. As my attention was caught by the simplicity and beauty of this apple, rational thoughts about the manipulation of materials were suspended; instead, I dwelled only on its form and the light that was reflecting from it. Something was impressing me about this apple, but I avoided attempts at defining it. It was not until much later, when I printed the negative, that I realized what I had responded to. The first few prints I pulled simply stated the subject as beautiful apple, and though it was pleasing, it seemed to lack the deeper impression I had experienced while making the negative. Something urged me to print it deeper in tone, and when I saw the new print, I was thrilled with its impact. The darker print allowed the surface reflections of the apple to shine forth as points of light, and I was amazed to see, not a rendition of an apple, but a galaxy of stars. I reflected on why I had not seen that exact potential in the apple when I first photographed it and realized that I was receiving the message on a deeper, subconscious level. In looking back at earlier successful photographs, I recalled that the same meditative stance had attended the process of making those images.

Another important event in my life at this time was meeting and marrying Eleanor, and since we were expecting a child, I thought it best to move back to Boston for a quieter atmosphere. I continued my consulting for Polaroid and supplemented finances by photographing architecture and teaching. During that year I dedicated myself to making the Sunflower series of photographs, and spent substantial time resolving my remaining questions about the Zone System and the Zen System. I endlessly tested films, papers, and developers in my darkroom in order to prove or dispel anything about these concepts that might help or hinder my photography. My realization that the medium is fraught with innumerable variables finally released me from the notion that one should, or even could, "pre-visualize" one's pictures. My goal was to keep technique in the service of the meditative attitude that allowed a deeper emotional participation. Rules, systems, and zones arranged neatly on a two-dimensional surface would not suffice.

The Zen System and the pursuit of spirit through photography, along with a number of other systems, became less of a burden to me when I emphasized doing instead of thinking. Too often I was finding that systems and exercises might point out where I was not, but this only left me in a state of desire and preconception about where I wished to be. I no longer sought the ritual of formula, but instead called on my "inner child" for a response to the situation of the moment. My "child" gave me understanding of my source and asked that I shed the accretions of information in order to find what already was. A long process of asking myself, "Is this it?" was replaced with, "Does this match the radiance of my inner child, once known and now remembered?"

The years of questioning were replaced by action in the moment. I was ready to move into the future. A year after the birth of John Paul, my first Guggenheim grant made it possible for us to sail to Ireland for the beginning of a remarkable adventure in a new land. There would be lambs and burros for my young son, new friends and Celtic lore for Eleanor, and, for myself, the mystery of ancient stones.

LIST OF PLATES

1. Birches, Vermont, c. 1973

2. Ipswich River, Ipswich, Massachusetts, 1960

3. Cattails, near Lubec, Maine, 1961

4. Wicklow Mountains, County Wicklow, Ireland, 1967

5. Redding woods and Little River, Connecticut, c. 1968

6. Redding woods, Connecticut, 1968

7. Little River, Redding, Connecticut, 1968

8. Little River, Redding, Connecticut, c. 1970

9. Little River, Redding, Connecticut, c. 1970

10. Redding woods, Connecticut, c. 1968

11. Little River, Redding, Connecticut, c. 1972

12. Pines, Poverty Hollow, Redding, Connecticut, c. 1970

13. Fungus, Essex woods, Massachusetts, c. 1962

14. Ravens Gulch, Lubec, Maine, 1961

15. Brewster, New York, 1963

16. Brewster, New York, 1963

17. Redding, Connecticut, c. 1970

18. Redding, Connecticut, c. 1970

19. Redding, Connecticut, 1967

20. Ipswich, Massachusetts, c. 1961

21. Boston, Massachusetts, 1960

22. Italian boy, Boston, Massachusetts, 1960

23. Ipswich, Massachusetts, c. 1962

24. Boston, Massachusetts, c. 1961

25. County Down, Ireland, 1967

26. Sunflowers, Revere, Massachusetts, 1965

27. Skullion, Lubec, Maine, c. 1961

28. Cabbage, Winthrop, Massachusetts, 1964

29. Shell, Ipswich, Massachusetts, 1961

30. Leaf, Winthrop, Massachusetts, c. 1964

31. Snake plant, Winthrop, Massachusetts, c. 1964

32. Dutch pipe plant, Brewster, New York, 1963

33. Essex woods, Massachusetts, c. 1960

34. Winthrop, Massachusetts, c. 1964

35. Fruit bowl, New York City, 1964

36. Pepper, Winthrop, Massachusetts, c. 1964

37. Sunflower, Winthrop, Massachusetts, 1965

38. Peaches, Hillsboro, New Hampshire, c. 1966

39. Doll, Boston, Massachusetts, c. 1962

40. Leek plant, Brewster, New York, 1963

41. Dried sunflower, Winthrop, Massachusetts, 1965

42. Beach, Revere, Massachusetts, c. 1965

43. Coventry, Connecticut, c. 1963

44. Nahant, Massachusetts, c. 1965

45. Boddisatva, New York, c. 1963

46. Ancient church, Glendalough, County Wicklow, Ireland, 1967

47. Church window, Glendalough, County Wicklow, Ireland, 1967

48. San Sebastian, New Mexico, 1985

49. Yosemite Valley, California, c. 1976

50. Yosemite Valley, California, c. 1976

51. Wicklow Mountains, Ireland, 1966

52. Essex woods, Massachusetts, c. 1965

53. The Flumes, White Mountains, New Hampshire, 1960

54. Coventry, Connecticut, c. 1963

55. Iced wall, Gloucester, Massachusetts, c. 1962

56. Tidepool, Nahant, Massachusetts, c. 1965

57. Tidepool, Nahant, Massachusetts, c. 1965

58. Beach stone, Hamilton's Cove, Lubec, Maine, c. 1961

59. Basalt, West Hartford, Connecticut, 1960

60. Schoodic Point, Maine coast, c. 1961

61. Pond, Massachusetts, c. 1965

SEASONS

was edited by Constance Sullivan.

Eleanor Morris Caponigro designed the book and
supervised printing.

Production was managed by Greg Graalfs and coordinated by
Alicia Hathaway.

This book was printed by Franklin Graphics,
Providence, Rhode Island,
and bound by Horowitz/Rea Book Manufacturers, Inc.,
Fairfield, New Jersey.

Four impression halftone photography by Robert J. Hennessey.

The type, Monotype Dante, was set by
Michael and Winifred Bixler, Skaneateles, New York.

The photographs are on Polaroid 4x5 Land Film Type 53,
Polaroid PolaPan 4x5 Land Film Type 52, and Polaroid
Positive/Negative 4x5 Land Film Type 55.